CREATE NOW!

CREATE NOW!

A Systematic Guide
to Artistic Audacity

by Marlo Johnson

CHRONICLE BOOKS
SAN FRANCISCO

Library of Congress Cataloging-in-Publication Data available.

ISBN: 978-1-4521-4602-7

Manufactured in China.

Book design by ALSO

10 9 8 7 6 5 4 3 2 1

Chronicle Books LLC
680 Second Street
San Francisco, CA 94107
www.chroniclebooks.com

INTRODUCTION

This book is fairly short, and you'll soon discover why. I wanted to create a simple but thorough system you can use every day that doesn't require weeks or months to complete. You can use it to create easier, more inspired, and more effective work now, but you can also use the process over a longer period of time to attain deeper and more profound results. You can go beyond just creating—to sharing your work, selling it, and using it as a tool for positive change. You can gradually peel back the layers that are keeping you from your full potential, taking the process exactly as far as you choose.

WHO NEEDS THIS BOOK?

This book was written with artists in mind, but it can be used by anyone who desires to have more creativity, clarity, and inspiration in what they do—with less procrastination! If you feel blocked in any part of your practice, from finding the original spark of inspiration to getting paid, this manual can help you through it. This guide is designed to be used for your creative tasks, but with enough practice, you will find that a more creative and positive state becomes a natural part of life in all you do.

HOW DO I USE THIS BOOK?

Prepare your workspace before you begin. Make sure you have all the materials needed to work on your chosen project as well as loose paper and writing tools. When it is time to begin, simply start at the beginning of Phase 1, answering the questions and following the corresponding instructions. This is meant to be done daily or every time you start a creative session until the process becomes second nature.

PHASE 1

Becoming a
Clear Conduit

Inspiration is not somewhere "out there," waiting to be found. You are a powerful and creative being already—so much so that you can even create the illusion that you are not. These techniques are designed to allow you to strip away this illusion, to help you realize the gifts you already have, and to allow your work to flow from a higher level of consciousness.

Using your own words, set the intention to let go of all blocks and negativity that are obscuring your creativity now. Then begin...

STEP

Do you have any basic physical needs to take care of at this moment?

A No. I feel great!

B I could be better.

C I feel horrible!

A Fantastic! Move on to Step 2.

B Do you need food, hydration, sleep, coffee, exercise, or something else? Fix what you can and then move on to Step 2.

C Perhaps you have more important things to deal with right now. Take care of whatever needs you can and then start over when you're feeling better.

STEP

Do you have any
emotional or mental
needs to take care
of at this time?

A No. I am happy and peaceful.

B I could be better.

C I am losing my mind!

A Lovely! Move on to Step 3.

B Perhaps you know exactly what's wrong or are just vaguely unwell. Either way, I recommend some therapeutic writing. On some loose paper, get out all the random thoughts, pent up emotions, and subconscious fears. Vent, scribble, doodle, explore. *Don't judge it.* Just purge anything and everything that comes to mind until you have nothing left. Be as ridiculous and extreme as you can! Let it all flow without hesitation and consider burning the evidence when you are done. Then continue to Step 3.

C Take some deep breaths. Maybe there's some serious stuff going on in your life, but let's focus on being okay for just this moment. Keep breathing and surrender to what is right now, as much as you can. Giving yourself love and compassion should always be a priority. When you're ready, start again from Step 1.

STEP

Do you have a clear vision of what you would like to create and why? Do you know your purpose?

A I have it all figured out!

B I have a vague idea.

C I have no clue!

A Good job! If you haven't yet, write this out as a mission statement for your practice and place it near your workspace as a reminder. Then move along to Step 4.

B It's time to narrow your focus. Create a mission statement for your creative practice. It should embody the highest goals of your life and work and give you purpose. What are you most passionate about? Ideally, what would your work be able to achieve for yourself or others? There is no right or wrong type of mission statement, and it can change over time. When you are done, put your mission statement somewhere as a reminder, and then move on to Step 4.

C A naturally flowing art practice should reflect who you are in the rest of your life, so let's start with that. What is important to you as a person? What do you think the world needs more of? What are you most passionate about? Find out what your priorities are and use them as a guide to write out a general list of themes that you may wish to explore creatively. Then return to Step 1.

STEP

So, you have a general direction for your work. Do you have the skills and technical information to execute it?

A I sure do!

B I don't feel
super confident
about that.

C Definitely not.

A Fantastic! Move on to Step 5.

B It sounds as if you need to practice some techniques! Don't be afraid of making mistakes. Do some experimenting, create some mock-ups, or find some other way to practice without pressure or expectations. If you lack the right knowledge, you'll soon find out what information you should seek. When finished, return to Step 1.

C You'll find an abundance of resources available these days, from library books to online video tutorials. Use your creativity to find an interesting and fun way to get the skills you need. Don't be afraid to play around and make mistakes. If you're not sure what you lack, just try learning as you go! You can always stop and do some research. Take at least one step right now toward gaining the skills you need. When you are ready, return to the beginning of Phase 1.

STEP

Do you feel ready
to create something
amazing yet?

A Heck yes!

B I feel great, but
I don't know how
to start.

C I suck, and/or
this sucks.

A Magnificent! Make sure you have everything you need and put aside all distractions. Set a goal for this session, take some deep breaths, and let the inspiration flow. You will know what to do. If your creative session flows well and you achieve today's goal, that's it! Simply repeat Phase 1 every time you start working until the project is complete. If any challenges arise, or you think the project might be done, continue to Phase 2.

B Prepare your space, free yourself of distractions, and take some breaths. Set a goal for this creative session, clear your mind, and then let go of all expectations of what might happen. When you feel ready, just start! You are opening the doors, and the inspiration will flow on its own. If you get stuck at all, use Phase 2. If not, just keep using Phase 1 each time you set out to work until you think your project is complete.

C It's time to get more serious. Dig deeply into your negative core beliefs and emotions. Do you have healing that needs to be done? Do you feel negativity that needs to be released? Using any medium you like, make some art to work out some of this stuff now. Your art doesn't have to be good—just use it to explore and release the heaviness you are carrying. For the maximum benefit, include as much extreme negativity as you can muster! Make it so ridiculously negative that you can't help but laugh. Feel free to destroy it when you are done. When you are ready, start Phase 1 again from the beginning.

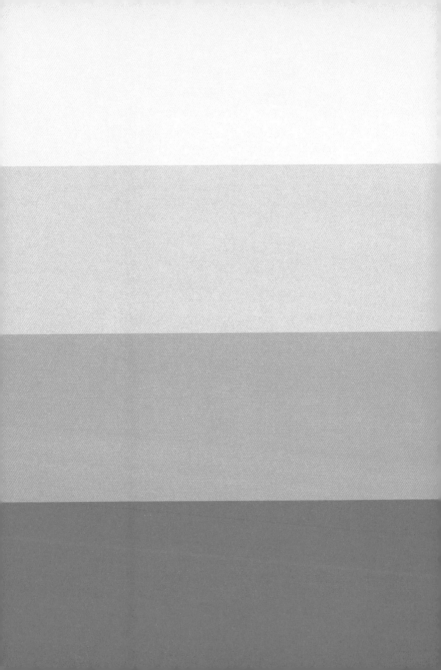

PHASE 2

Creation and
Completion

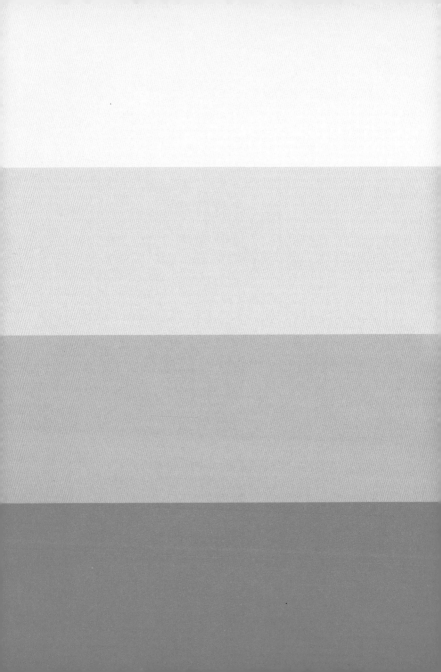

The creation has begun. You know how to start the flow of creativity, so now let's talk about how you stay out of your own way so you may sustain this state all the way to project completion. And how do you know when the work is complete?

For this phase, set the intention to allow the work to become what it is meant to be, without expectations, and then continue.

STEP

You now have a project underway. Do you think it is finished?

A Yes. It is perfect!

B I don't know!

C Definitely not!

A How exciting! You may choose to start again from the beginning and make something new, or you may move on to Phase 3 if you wish to share your work.

B I consider work to be done when there is nothing left to add, remove, or change to create the most clear message possible. You may not even know exactly what the message is, but you can learn to tell if it is clearly executed or not. So, go back and see if this is the case with your work and then begin this phase again from the beginning.

C Are you putting too much pressure on yourself to create right now? If you feel this is true, take a break or wrap up for the day. After a creative session, I recommend doing something grounding, like going for a walk, having a shower, drinking some water, breathing and consciously looking around, or just lying on the ground. You may feel a bit spaced out, so take some time to come back to Earth! If you don't need a break, continue to Step 2. Otherwise begin at Phase 1 when you are ready.

STEP

Do you think you would benefit from going back to the beginning of Phase 1 and addressing the issues covered there? Do you perhaps need some food or have some negativity that is blocking your progress?

A No. The challenge I'm experiencing is new!

B I don't know.

C Yes.

A Close your eyes, take some deep breaths, and relax for a few minutes. Inspiration can flow if there is a clear space for it to do so. Can you create this space without interfering, judging, or creating expectations? If you are inspired to get back to work at any time, do so! Otherwise continue to Step 3.

B Just to be safe, do a quick run-through of Phase 1 and see if there's something you missed. It's great to practice the process anyway!

C Good idea! You may begin Phase 1 again now.

STEP

So you started a project, but now you are having trouble finishing it. Do you have any fears about finishing or continuing the work in the direction it's headed? When you think about finishing or continuing, do you have any negative reaction at all?

A No. I'm excited to finish!

B Maybe? I'm not sure how I feel.

C Yes! This sucks, and/or I suck!

A Great! Take a few minutes to relax and breathe and then ask yourself the following question: "What steps should I take now toward finishing this project?" Use your intuition; deep down you probably know what to do. Write down any answers that come to you and then continue to Step 4.

B If you are unsure, perhaps your feelings are subconscious? Get your writing materials and answer the following: "What is the worst thing that could happen if I continue and finish this project?" Include everything that comes to mind. Does it seem as if any of this is affecting you? Use your intuition to find a way to address what is needed and let all fears and negativity go. Replace all these negative ideas with positive affirmations: the things you'd truly prefer to believe and see happen. Next, continue to Step 4.

C This is the ego talking. Does that seem contradictory? Well, the idea here is to let go of what you think, want, or expect and to allow the work to unfold in ways that might be beyond what your rational mind can grasp. If you are judging the work or trying to control its outcome, then the ego is taking over. Let go of all expectations and negativity about the work in progress now and then move on to Step 4.

STEP

Okay. Are you ready to continue and/or finish this thing yet?

A Yes!

B Maybe?

C No. Kill it with fire!

A Yay! Now get to work! Keep repeating this guide as needed from Phase 1 until you know the work is complete. Then you may move on to Phase 3!

B Let's just try it and see what happens. I believe in you! If you get stuck, begin again at Phase 1. Repeat this until the work is finished and then read Phase 3.

C It's okay to give up! Sometimes we need to give a project a break, and sometimes we need to throw it into a fire. Starting fresh is often easier than reworking something that's not right. It's up to you! Just remember to keep trying even if certain projects don't work out. You're not a failure; it's just part of the learning process! When you're ready, start again at Phase 1.

PHASE 3

Sharing Your Work

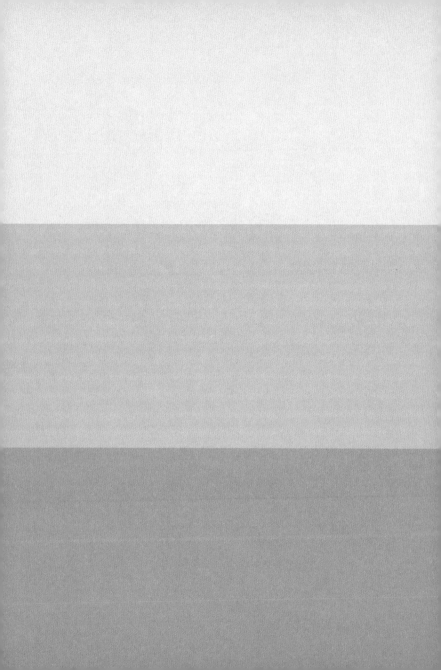

The time may come when you want *or need* to share your work with others. It's okay if that's not part of your plan, but for many of us, it's vital to our mission statement or livelihood. The idea is not to try to sell the work but instead to make connections with those who will most resonate with the work (which leads to sales naturally if that is one of your goals).

Set your intention now to share your work openly so those who will truly appreciate it and benefit from it the most may see it.

STEP

You made something. Great job! How do you feel about what you created?

A I feel good about it.

B I'm not sure how I feel about it.

C I have negative feelings about it.

A Great! You may move on to Step 2.

B Is it possible that what you created is amazing and that you are just feeling unsure due to fears or negative beliefs? To find clarity, write out a list of all your feelings, then start this phase again.

C Why do you have negative feelings about what you made? Does it go against your mission statement or who you are as a person? Do you feel it is below your quality standards? If it truly goes against who you are, you may not want to share it. Perhaps it was part of your learning process but is not meant to be put out into the world. You should make sure that it represents you positively and that you will feel good about people seeing it for a long time. Start at Phase 1 and see if any changes need to be made.

STEP

If you're on this step, you should have some work that you know is good. You may even feel as if it has its own purpose to fulfill in the world. How do you feel about sharing it with people?

A I'm excited to share it!

B I have mixed feelings.

C I don't like that at all.

A Awesome! You are ready for Step 3.

B Get your writing supplies and explore this. Make a list of all the worst things that could happen if you put your work out there. Look at the points you have listed. Do your worries seem a bit more silly than you thought? It's possible that there's some truth in what you fear, too, but it's important to take some risks to fulfill your goals and to grow as a person! Decide now to take at least one small step toward sharing your work and then move on to Step 3.

C Can you change or redo the work (without negatively compromising it) so you would be okay with sharing it? If not, make a list of all your fears about sharing your work. Look at each one. Are they really true? How many of them come from negative programming from society or cynical people in your life? Eliminate any negative beliefs you find obviously false and write out positive ones to replace them. If there are any you can't eliminate now, can you face them by sharing your work anyway? When you feel willing to start sharing your work, even in a small way, you may move on to Step 3.

STEP

You should feel good about your work and be ready to share it now. Do you have a system for doing so?

A Yes! I'm totally prepared already.

B Yes, but I'd like to change or expand it.

C No. I'm starting from scratch.

A Great! Let go of all expectations and share away! Remember to remain aligned with your mission statement and let your network blossom naturally. When you want to learn about getting paid for your work, begin Phase 4.

B With your mission statement in mind, write down some new and exciting ways you could show your work to others. Let go of all preconceived ideas about how it should be done and what you should expect from others when you do so. You may even wish to let go of some of your old sharing methods if they no longer resonate with your purpose. Which ideas can you act on right now? Start small and see where your actions lead. When you are ready, move on to Phase 4.

C It's time to build your network. This is not "people I'm trying to get things from." It's just a web of your respected friends, peers, family, or other like-minded people. Using the methods you have learned in this book, first address any fears or negativity you may have about networking. Next, use your creativity to write down some exciting new ways to reach others that are in line with your mission statement. How can you best help others and create value in the world? What resources do you have access to? Do you know anyone who would be willing to help you? You will find endless ways to reach people, online and otherwise. Take at least one small step to expand your network right now and see where it leads. Move on to Phase 4 whenever you're ready.

PHASE 4

Receiving
Payment

You deserve to receive fair payment for what you do. What does this mean? If you create something of value for someone else, you should get something of equal value back. Often this means money, but it may be easier to expand your expectations to include other things, too. I don't mean goats—I'm talking about things you really need! So, you put your work out there. How do you get paid back?

For this stage, set the intention now to value your work honestly and to allow yourself to receive the proper support back from the world.

STEP

Have you placed
any expectations on
how you should be
paid for your work?

A None at all.

B Maybe a few.

C Yes. I need money!

A Perfect! If you keep your options open, you are more likely to receive. Go to Step 2.

B Perhaps you are keeping your options open, but are you being creative enough? You will discover endless ways to trade what you do for something of value that you need or want. Access your flow of inspiration and write down any ideas that come to mind. Don't be afraid to talk with people who might be able to help! When you are finished, move on to Step 2.

C This is totally valid. Move on to Step 2.

STEP

Do you feel grateful for what you already have? Do you appreciate what you have already gained in creating and sharing your work?

Yes.

Somewhat, but I
still lack things.

No.

A Lovely. Acting with gratitude goes a long way toward helping you receive more of what you need and fostering loyal clients! Move to Step 3.

B Make a list of what you currently appreciate in life, including things about your creative practice. Next, make a list of new things you would be grateful to have come to you. Cross off those things you can already trust to come in time. Is there anything left? Look at what you would have to change in your attitudes and habits to receive these things in your life. Do you need to be more positive, focused, or creative? Write down what specific changes you will make to better align yourself with your goals. When this is complete, you may move on to Step 3.

C If you aren't happy with what you already have, will getting more things make you feel any better? Could you be creating the illusion of lack with your attitude of ingratitude? Access your higher creativity to explore these general ideas on some paper. Vent about any feelings of lack or deprivation. Then, see if you can find anything in life to appreciate. Make a list of at least ten things you are grateful for and then continue to Step 3.

STEP

Do you place the proper value on yourself?

A I feel well valued by myself and others.

B I don't feel very confident about my worth.

C I feel undeserving or worthless much of the time.

A This is great! Continue to Step 4.

B If you live under the illusion that some people are better than others because of how they look, what they do, or other attributes, let this go now. You, and your time and energy, are important. We all have the same intrinsic value that cannot be changed. Using your imagination, create a daily reminder that you are equal to everyone else and *completely stop thinking and saying negative things about yourself*! This will help you rise to your full potential. Then continue to Step 4.

C Anything that makes you think you are worth less than anyone else is *wrong*. Anything that makes you think you can be devalued based on anything you have done, haven't done, your appearance, race, age, or anything else, is *wrong*. The intrinsic value of all people *is the same and can never be changed*, and this counts for you, too! Take some time to write down your negative beliefs about yourself and notice how they came from a place of fear, not truth. You probably wouldn't say these things to a friend, and you should have the same compassion for yourself. Write some positive affirmations to keep yourself on track and display them somewhere that you will see them daily. Move on to the next step, but remember to repeat Phase 4 often.

STEP

Do you place the proper value on your work?

A Yes, and I am confident about it!

B I don't know.

C No. I just take whatever I can get for it.

A Excellent! Move on to Step 5.

B First, consider the amount of time and other resources that went into what you made. The final value should include a fair hourly wage and expenses at the very least! You must also consider the amount of training, practice, and money that went into developing your skills. Next, consider the positive effect your work has on people; if you focus on creating value for others, it is easier to stand behind your prices. Use your intuition and write out what you think your work should sell for. When you have some numbers that you can confidently give when people ask "How much?" you may continue to Step 5.

C You are always free to discount your work or give it away, but do you know the reasons you do so? Explore them. Do you have positive intentions, free of expectations? Or do you do so out of fear, negativity, or the desire for a certain outcome? With your mission statement in mind, create a set of rules for when to give your work away or discount it (such as for charities) and when you should expect full price. Write them down so you aren't caught off guard when someone wants free or cheap work. When you are done, start Phase 4 again.

STEP

Do you feel too attached to your work to let it go?

A No. I'm happy to see it go to a new home.

B I'll let it go for the right price.

C Yes. I don't want to part with it at all.

A This is good; just remember its value! Continue to Step 6.

B Great! It sounds as if you value your work; just remember you have access to endless amounts of creativity if you want to make more. Move on to Step 6.

C Where do your negative feelings about parting with your work come from? Letting feelings of attachment or scarcity enter your practice can cause you to price your work too high and make you or your customers feel negatively even if you do let it go. Remember that you have access to all the creative energy you desire and can always make more. It's okay to keep your work if you like, but letting it go on to enrich the lives of other people also has great value. What fits your mission statement best? If you still feel too attached to your work, try creating a larger collection of completed projects and see if this changes your feelings. If you are ready to sell something, continue to Step 6.

STEP

Do you feel completely positive about receiving good things like prosperity, love, health, and happiness?

A Yes—100%!

B Not all of them.

C Not any of them.

A Great! Move on to Step 7.

B Starting with prosperity, love, health, and happiness, make a list of good things you would like in your life, whether you have them already or not. One by one, visualize receiving each of them completely. Which ones trigger negative or conflicting feelings? Explore these. What are you afraid of happening if you get what you say you want? Keep exploring your thoughts and feelings until all your negative beliefs become clear. Using your imagination, find a way to let go of these beliefs. Can you visualize yourself receiving all these good things now with ease? Continue to Step 7.

C Why do you believe you should have a difficult and negative life? Take some time to explore these beliefs with writing or art. Where did these ideas come from? They are undoubtedly not really in line with your true self. Once you have some clarity, let go of this negativity. You have the power to create a happier and easier life now, and you deserve to. Create some positive affirmations to remind you to do so and display them where you will see them often. When this is complete, move on to Step 7.

STEP

Can you truly see yourself being successful in the ways you prefer?

A Yes, definitely.

B I'm not sure.

C No.

A Fabulous! Trust that this will happen when the time is right, if it hasn't already. You have all the tools you need; just remember to repeat each phase of this book often! Your goals and creative projects may change, but your formula for success will remain the same.

B When you think about being successful, do any negative feelings come up? This is surprisingly common. Write down a list of everything that you feel. Write out the absolute worst possible scenarios of what might happen if you become successful. Make it as extreme and as ridiculous as possible. Take an honest look at these beliefs. Can you let them go now? Know that you are deserving of success, and there is nothing real to fear. Just remember to take things one small step at a time and to repeat each phase often!

C Do you need to change your expectations to be more realistic? Have you gone through this program honestly and thoroughly enough? You may just need to practice the methods for a while still. Take small steps toward your goals, and they will become more believable the closer you get. Take some deep breaths, clear your mind, and honestly ask yourself what is needed now. Is it time to start over at Phase 1?

You have now completed the program and, hopefully, a full circuit of the creative cycle all the way to getting payment for your work. This full circuit is needed for a flourishing creative career or any prosperous life. We cannot just create and give—we need to keep ourselves replenished so we can create more. Remember it is all a circle with no real destination, but we can spiral upward with every loop. As long as you are growing and learning, you are a success! Congratulate yourself for what you have accomplished and celebrate!

CONCLUSION

What would it be like to live without any fear? What if you could be yourself completely, do what you love, have it support you, and allow others to do the same? Can you imagine this? What if we could all live this way?

This book can help get us there. Use these methods as often as you can, going deeper into your core beliefs each time, and you will find yourself closer and closer to this freedom every day. This is not just about making art— this is about living every day with complete honesty and love, finding out who you truly are, and living always as that person. Release the imaginary limitations of your mind and bloom.

Notes

Notes

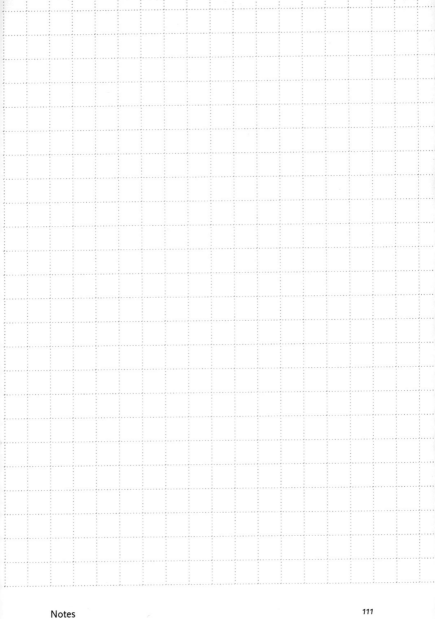

Notes